The Kids' Book of Creative Lettering

by Lindsay Ostrom and Friends

This book belongs to

Write your name here!
Do it Cute!!!
Practice first!

Cut-it-up ™

PO BOX 287 · Gold Run · California 95717

530 389-2233 fax 530 389-2244

★ Dedication ★

Vicky and Lindsay
and all their kids!

This book is dedicated to all our children; Carly, Bailey, Kurtis, and Riley. They keep us forever young and teach us what's cool and hip!

I'd like to thank all my teachers who put up with all my wacky lettering styles and my constant doodling in class. Never give up on your dream... it may just come true! Keep on doodling!

Thank You
for your support!

Lines from Lindsay

I wrote, lettered, and illustrated my first book, Bobby the Pig, at age 9. I saved it and look at it every now and then. It wasn't very good, but writing, lettering, and doodling have been my passion ever since. My earliest calligraphy class was when I was 12 with Sister Mary Teresa Dodge and I still take lettering classes now at 42 years old! You're never too old, or too good, to learn something new. You're never so good at something that you don't need to practice, whether it's a sport, a musical instrument, dance, or whatever. You always need to practice, and always need to challenge yourself to learn more. I hope this book will teach you some basic skills about creative lettering. More than that, I hope this book will inspire you to create masterpieces with the lettering you learned. From the very start, keep a file of your practice pages. They may look terrible, but every few weeks look back at what you did last. You'll be amazed at how much better you get each time you practice. If you don't think so, make a card and give it to a friend; he or she will be amazed! Have fun and don't forget, practice makes perfect!

Happy Lettering!

Lindsay

Table of Contents

Tools . . .

Before you can get started in creative lettering, you need a few tools. Just like building a house or baking cookies, you can't begin without a hammer and nails or a mixer and chocolate chips! With creative lettering, it's the same. Here's a list of the basic items. Remember, it's "Creative" lettering. So there are lots of other tools you can use to be really creative. Don't limit yourself to just what I've listed here. OK, let's get started!

- a pencil

A #2 is good, but a mechanical one is best. It's always sharp.

- a ruler

The see-through type is the best for making very straight lines.

- pens

gel pen felt-tip markers calligraphy tip brush tips

Lots of types of pens with different-width tips. Try lots of colors, too!

- an eraser

eraser click type

A white one is best. Either a flat one or a click-up pen type.

- paper

Notebook paper is good or use the practice sheets at the back of this book. Try black paper with gel pens.

- colored pencils

These are fun to shade and blend colors with.

- crayons

crayon

These give you a thick, scribbly type line. They're very fun!

- What other tools can you think of to try out?

4

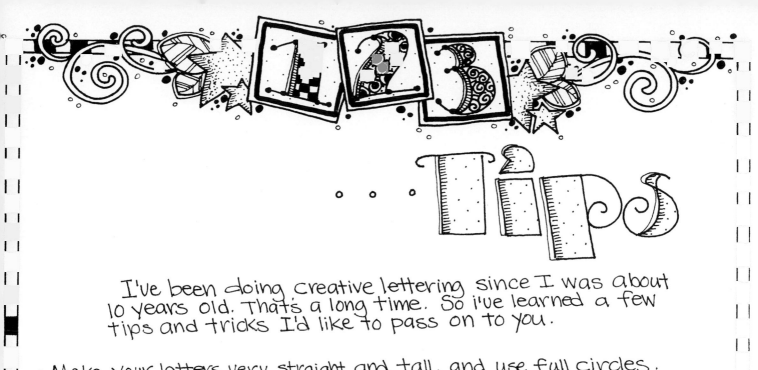

... Tips

I've been doing creative lettering since I was about 10 years old. That's a long time. So i've learned a few tips and tricks I'd like to pass on to you.

- Make your letters very straight and tall, and use full circles. The letters on the left are bad. The ones on the right are good!

ABCDEF UPPER-CASE ☆ ABCDEF

After you practice a bit, you can get more creative. If you handwrite in cursive, practice printing more and your handwriting will get better, too.

OCeu lower-case ☆ OCeu

- When you write a word, notice how you space and place your letters. Try writing your words lots of different ways. Space them close together and far apart. See which way you like better.

CLOSE FAR Normal

- When you are practicing, give yourself a set amount of space to write a long word and then a short word. Make sure the word fits within that space exactly. That will help you learn how to space and place your words.

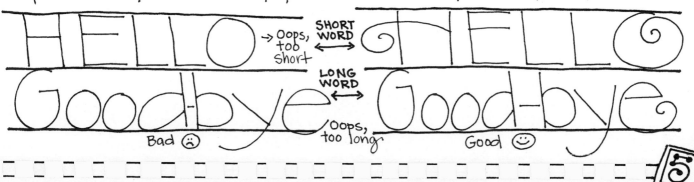

Tricks...

Now that you have the right tools and you've gotten a few helpful tips, let's learn a few tricks.

· Trace — When you just can't get the hang of one of the alphabets, like "FLASH," trace it. Put a piece of copy or laser paper over the page and trace it. Do this several times. Practice over and over, until you can do it on your own. It doesn't have to look exactly like mine. Make it yours—!

· Dots — Make the dots in your "Polka Dots" as round and filled in as possible. Slow down and take your time. This alphabet is a two-step process. First, do all the letters in the word. Then go back and add the dots.

Bad Dots ← ☹ **Good Dots** ← ☺

· Embellish — I learned this word in 6th grade and it's still one of my favorites. It means to add a little bit extra. Embellish your words by adding swirls, curves, dots, dashes, etc... Try to embellish the first and last letter in a word. See how I wrote "Embellish"? Cool, huh?

Style — When you are doing a poster or a book report cover, you want it to stand out above the others. Here's where the "Creative" part of creative lettering comes in. Add a flourish to any letter that goes above the line or below the line. Like "T,F,L,Y,P" and others. And here's where some doodles come in handy. "Go wild" lettering works well here. Use lots of color combinations too for extra style and flair.

6

more ...Tricks

• COLOR

This book is done in black and white, which is good for learning and tracing. But look how cool the cover and back of the book look! Go to the library and get a book with a color wheel. It will show you colors that go together — complementary colors. Or try color combinations on your own. Use a light color with a darker shade of that same color on the top, like light blue and dark blue. Try holiday colors or your school colors. Use different tools for this - chalk, colored pencils, gel pens, glitter pens, and markers. Color is cool!

• THE WAVE

Try doing your writing on a curve. It's a fun way to write a poem or send a letter to a friend. Do it small or do it big. It's fun to address cards and letters like this. Draw lines in pencil and erase them when you are done. Don't get seasick!!!

Make all the wavy lines different widths and heights. Fun, huh?

THE OSTROMS
P.O. BOX 678910
COLFAX, CALIFORNIA

↓ Do this in all caps. It works best that way.

• practice PRACTICE practice

and then practice some more♡

Maybe you're good at soccer, piano, cheerleading, or basketball. You wouldn't be very good if you didn't practice. The same is true for creative lettering. Start a file and keep all your practice sheets. It's fun to look back at them when you are a pro! Also get a blank book or a journal. Write all the time. Write words, poems, stories, or just how you feel. Your lettering will improve each time you write. But keep practicing. It's fun and it's creative!

Ready, Set, Go!

Upper- and lowercase printing with a bit of style.

AABBCCDDE
FFGGHHIJ
JKKLLMMNNO
PPQQRRSTU
UVWWXYYZZ

Find your own
style and Flair

Break some rules
and be creative.
But don't tell
your teacher.

Back to School

SCHOOL
days

Add a
swirl
or
two.

t·e·a·c·h·e·r's
PET

← space
it out.

Thow a
curve
into
it.

← Try all upper-
or lowercase.
Mix and match!

Ready, Set, Go!

aabbccddeeffg
ghhiijjkklmmn
hoooppqqrrsstt
uuvwwxxyyzz

1122334456778890

♡ when you're being creative, there is no right or wrong way. ♡

Go wild
HOMEWORK
Place the letters up and down.

Make your letters
Thick.
And try them
thin.

ALTA
school
Don't be afraid to doodle.

Mrs. Westmoreland
Outline the letters and add some extra doo-dads.

Add a doodle in your "O"s.

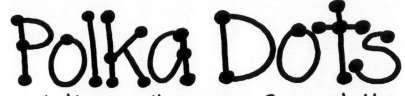

Polka Dots

☙ A variation on the game Connect the Dots. ❧

With this style, you need to master the "Ready, Set, Go" style first and then add some dots. You need a dot wherever you want to connect a line. Make sure your dots are nice and round and your letters are straight and tall. When you've got that, add extra dots, lines, outlines, swirls, or whatever else you feel like ___.

ABCDEFGHI
JKLMNOPQ
RSTUVWXY
Z 1234567890

Practice with your favorite names
or the names of your friends, family, and classmates.

Shannon

Try
lettering the names
in lots of
different ways.

Kurtis

Riley

Bailey
Jill

JORDAN

Polka Dots

a a b c d e f g h i j
k l m n o p q r s
t u v w x y z

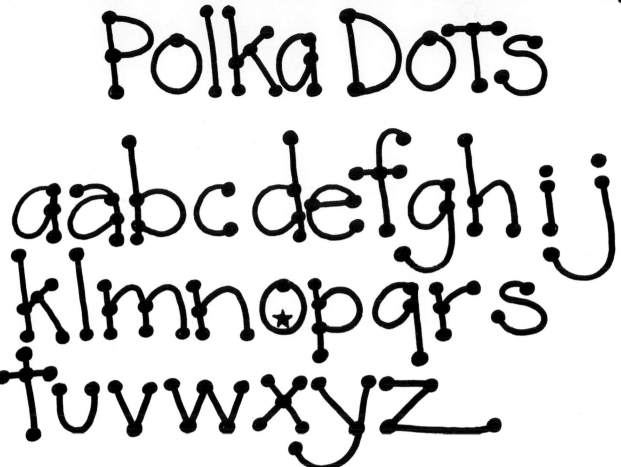

Carly

Add a frame →
and a doodle.

Don't forget some of your
basic spacing and placing tricks.

Jason

Get a
little
SHAKY →

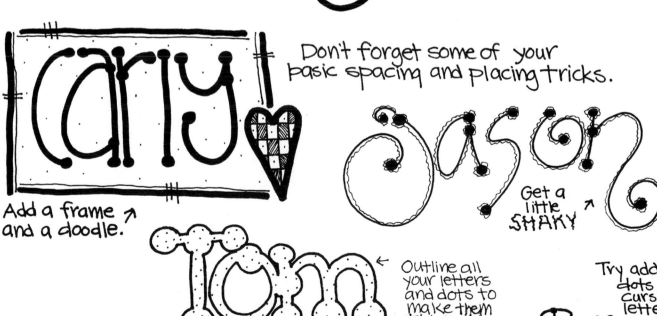

Tom

Outline all
your letters
and dots to
make them
thicker!

Try adding
dots to
cursive
letters. ↙

Ben
&
Jack

VICKY
LYNN

BRENT

Connect all the
letters together. ↗

Beyond Dots

Now that you've mastered the "Polka Dots," ...try these variations. Practice them in a regular printing style and then try them in a cursive style. When you get really good, use the "Balloon" lettering. (That's coming up next!)

You've already learned the lettering. Here are the additions.

stars ☆ hearts ♡ squares □ swirls ◎ triangles △ raindrops ◊ dot·n·dots ⊙ flowers ✿ faces ☺ Try your own!

Zayna — hearts

TIANA — swirls

nastacia — Try it in cursive.

stars — *Brad[c]y*

kids' faces — *Jacob*

Use doodles as spacers between your letters — *COREY* — triangles

LIBBY — flowers

Beyond DOTS

Here are a few more ideas.

Emily

dot·n·dots

Whitney

open dots

Try polka dots on cursive.

Stephanie

wiggly raindrops

Matthew

Kristin

tall and thin letters with squares

Try it with "Balloon"— an outlined dot.

Laurie

Mix caps and lowercase for a fun look.

Write the word first. Add big puffy dots. Then outline.

Laurie

Erase your inside lines. Now try this with all the other variations. ♥, ☆, △!

Balloon

For this lettering, you begin with the "Ready, set, Go" printing and then outline the letters. You can square off your edges for a sharp look or round them off for more of a balloon effect. Follow steps 1, 2, and 3.

step 1 • Write a word in pencil. (Leave some room between the letters for outlining.)

Balloon

step 2 • Draw around each letter in pencil. When each letter is just right, trace over it in pen.

Balloon

step 3 • Let the ink dry and erase your pencil lines. Fill the letters in with color and all kinds of doodles.

Balloon

Round off the letters and try connecting them.

Balloon

Add some doodles or some little lines. Make them look like stitches.

Balloon

Balloon

Here's an alphabet to copy if you need a little extra help!

Aa Bb Cc Dd
Ee Ff Gg Hh
Ii Jj Kk Ll
Mm Nn Oo Pp
Qq Rr Ss Tt
Uu Vv Ww Xx
Yy Zz

1 2 3 4 5 6 7 8 9 0 ✪

The thick plackline in the center of each letter gets erased, leaving only the outside outline.

GROOVY

Do this lettering the same way you did the "Balloon" lettering.

★ Write the word in pencil.

GROOVY

★ Now outline the letters in pencil. Make them puffy.

GROOVY

★ Add in the GROOVY doodles.

GROOVY

★ Outline in pen and color in the letters. Don't forget the 60's colors were lime-green, orange, yellow, and hot pink.

GROOVY

★ Now get groovy with it, baby. Do all the same doodles or mix them up.

Flower child

Groovy Doodles ↓

Groovy

Aa Bb Cc Dd Ee
Ff Gg Hh Ii Jj
Kk Ll Mm Nn Oo
Pp Qq Rr Ss Tt
Uu Vv Ww Xx
Yy Zz

Make your own doodles to design more alphabets.

17

BLOCKHEADS

A cool slashed lettering set into blocks.

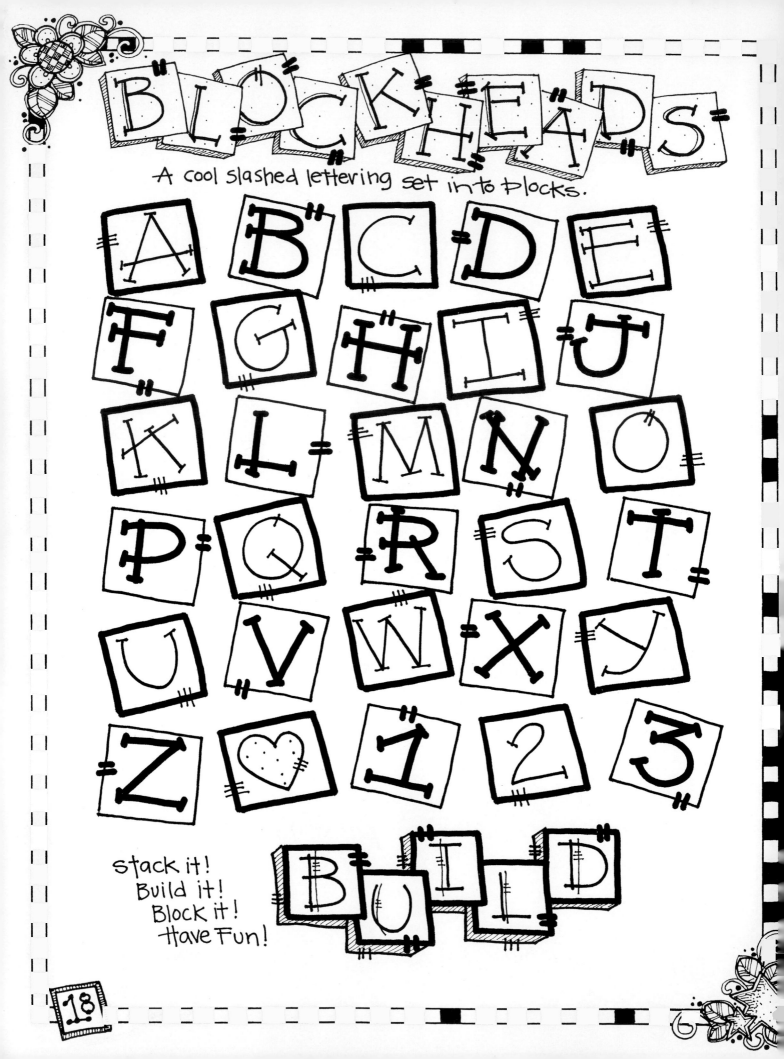

A B C D E
F G H I J
K L M N O
P Q R S T
U V W X Y
Z ♥ 1 2 3

Stack it!
Build it!
Block it!
Have Fun!

BUILD

18

BLOCKHEADS

When you put the letters in blocks, it's best to use all capital letters. This is a serif alphabet. That's what the slash marks are called, serifs. The slash marks go at the ends of the letters. You can add extra slashes (serifs) in different widths to look like stitches.

Aa Bb Cc Dd
Ee Ff Gg Hh
Ii Jj Kk Ll
Mm Nn Oo Pp Qq
Rr Ss Tt Uu Vv
Ww Xx Yy Zz

STACK

BLOCK

Try other lettering in the blocks, too!

Sewing Class

All Grown-Up

A kids' guide to easy calligraphy.

right-handed hold

left-handed hold

Calligraphy Pen

You'll need to use a pen with a flat, wide tip to make your lettering look like real calligraphy. If all you have is a regular felt-tip pen, that's ok, too. You can form the letters the same way, but you won't get all the cool thin and thick curves in your letters. Start by putting the flat end of your pen against the diagonal line in the box to the left. (Use the bottom box if you're a leftie.) That's a 45° angle and the correct way to hold your pen so you can do this.

First practice by making a zigzag or a wavy line. Do this several times. Yours should look like these.

Aa Bb Cc Dd Ee

These letters were done by using a regular felt-tip pen. Don't they look "All Grown-Up"?

Ff Gg Hh Ii Jj Kk

Ll Mm Nn Oo Pp

Qq Rr Ss Tt Uu Vv

Ww Xx Yy Zz

Want to see more calligraphy styles? Go to your library and check out some books. There are many other styles to learn.

A Grown-Up

These letters were done using a real calligraphy pen.

Aa Bb Cc Dd Ee
Ff Gg Hh Ii Jj Kk
Ll Mm Nn Oo Pp
Qq Rr Ss Tt Uu Vv
Ww Xx Yy Zz

❖ 1234567890 ❖

Try some fancy doodles. →

Put it all together

Squish your letters together and make them connect to each other.

I think you're doing a great job. ☺

Doodle-I-DO

This lettering breaks all the rules. Have fun with it!

A B C D E F
G H I J K L
M N O P Q
R S T U V
W X Y Z

Use a crayon or colored pencil to make the letters look like they were written with chalk. **CHALKBOARD**

PLAYGROUND Try it scribble-y.

Do it straight. **PRE-SCHOOL**

Doodle-E-Do

A great style to doodle designs into!

a b c d e f g h i
j k l m n o p q
r s t u v w x y
z 1 2 3 4 5 6 7 8 9 0

Add these doodles:

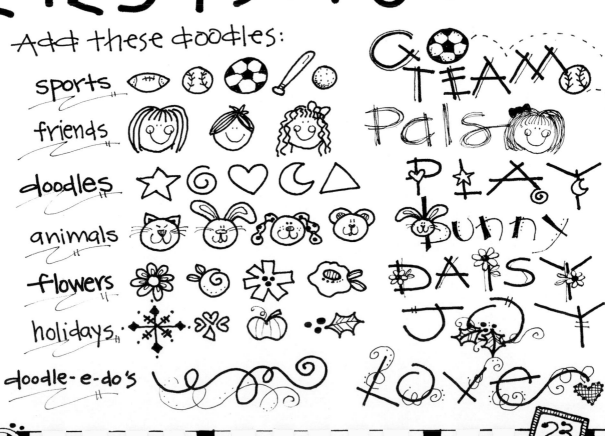

sports

friends

doodles

animals

flowers

holidays

doodle-e-do's

FLASH

Add sparks to your lettering.

A B C D E F
G H I J K L
M N O P Q R
S T U V W
X Y Z

How to make the flash.

① Start with a backwards check.

② Add another check.

③ Then add a curved line.

④ Now do it again a little bit away from the first flash.

⑤ Meet at the ends.

← Use a glitter pen, a gel pen, or a metallic pen to add some sparkle to the flash.

HOT NEWS!

FLASH

For the "Flash" lettering, write the letters first in pencil. Then make the lightning bolt in pencil and go over everything in pen.

a b c d e
f g h i j k l
m n o p q r s
t u v w x y z

For the lowercase lettering, add some stars and asterisks to look like little sparks of light!

News FLASH

SCIENCE FAIR

YEARBOOK meeting

MOVIE STAR

This style makes you feel like a star.

A — Do your basic letter shape in pencil first.

A — Make the letter thicker on the left side. There are a few exceptions— J, Y and Z are thicker on the right side.

A — Add your swirls and fill them in.

A B C D E F
G H I J K L
M N O P Q R
S T U V W X
Y Z

Squish the letters together.

TRY

Leave the swirls out to make the letters bolder!

GRAD NIGHT

Fill in the letters with color or designs.

Congrats!

MOVIE STAR

abcdefg
hijklmn
opqrstu
vwxyz Z

☆ 1 2 3 4 5 6 7 8 9 0

It's best to do your letters in pencil first. Then go over them in pen and erase the pencil lines (at least while you're learning).

Cheer

←TILT your letters forward and backward for a cool look!

Dance
T·O·N·I·G·H·T

←Make the shadow blocks THIN!

Study
H·A·L·L

DRAMA
class

←Fill in the letters with cool doodles!

27

BUG out!

Bug your buddies with silly bug writing!

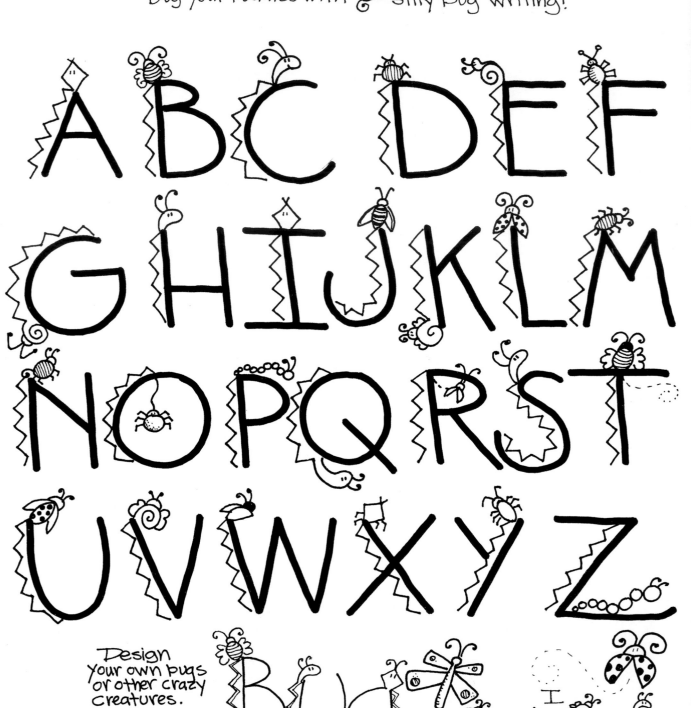

A B C D E F
G H I J K L M
N O P Q R S T
U V W X Y Z

Design your own bugs or other crazy creatures.

BUG COLLECTOR

I LOVE BUGS

BUGout!

a b c d e f g h
i j k l m n o p
q r s t u v w
x y z

Add other doodles besides just bugs!

For the lowercase letters, leave out the bugs so it's not too crowded. Just do the zigzag part. (Get ziggy with it!)

you BUG me

my REPORT on insects

Or just add a few bugs!

mrs. MOSER

world's best science teacher

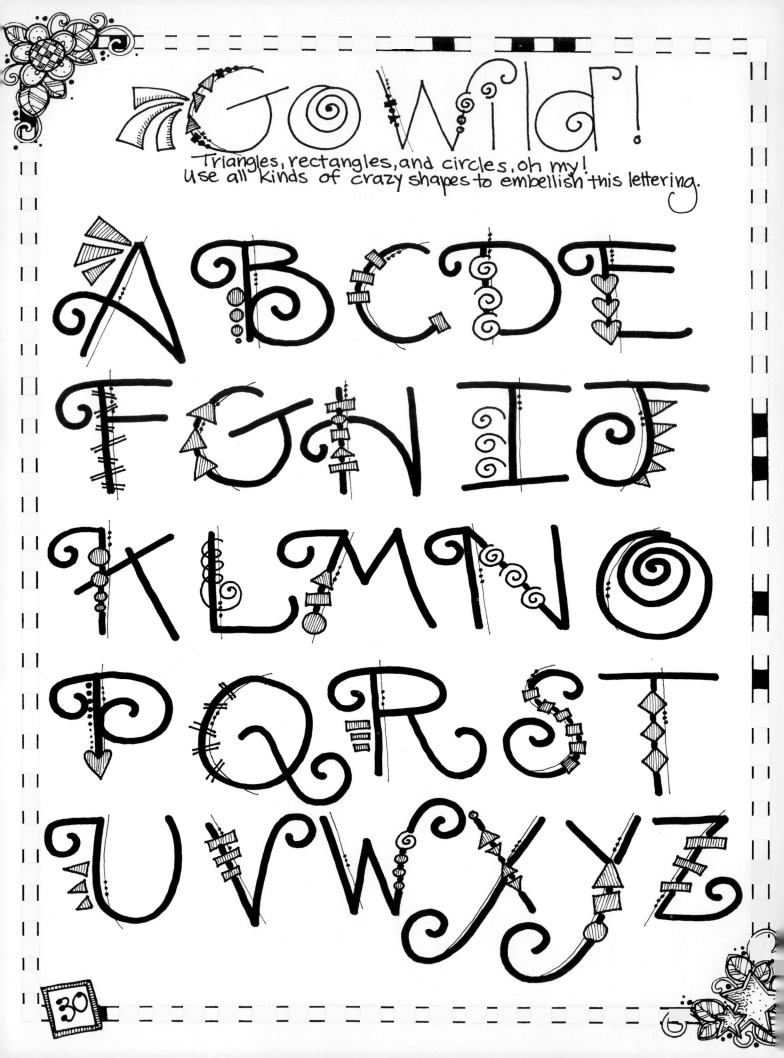

Go Wild!

Triangles, rectangles, and circles, oh my!
Use all kinds of crazy shapes to embellish this lettering.

A B C D E
F G H I J
K L M N O
P Q R S T
U V W X Y Z

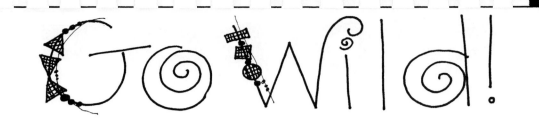

Go Wild!

a b c d e f
g h i j k l m
n o p q r s t
u v w x y z

1 2 3 4 5 6 7 8 9 0

come to my PARTY

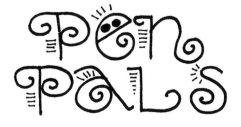

PEN PALS

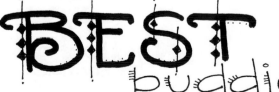

BEST buddies

← Use all the same doodles in each of the letters.

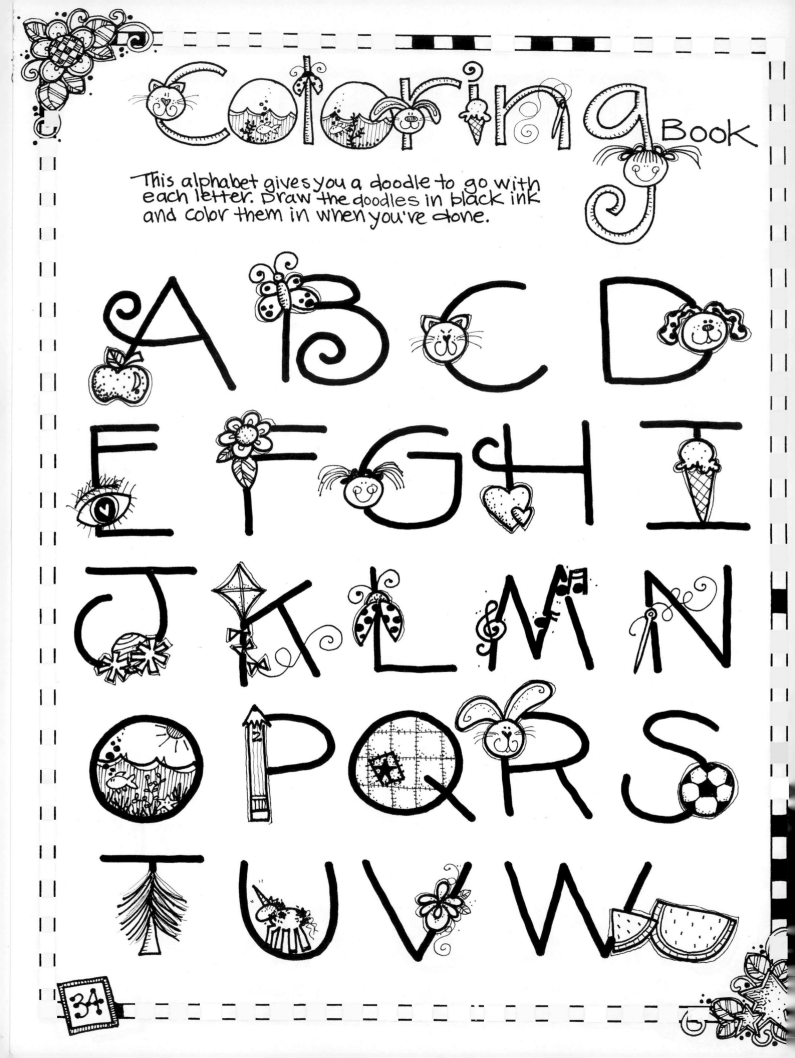

Coloring Book

This alphabet gives you a doodle to go with each letter. Draw the doodles in black ink and color them in when you've done.

A B C D
E F G H I
J K L M N
O P Q R S
T U V W

Coloring Book

X Y Z

xoxoxox

Try these same doodles with different lettering styles.

Library
assistant

HALL
P·A·S·S

Student
council

Use sports' balls or other doodles.

COACH

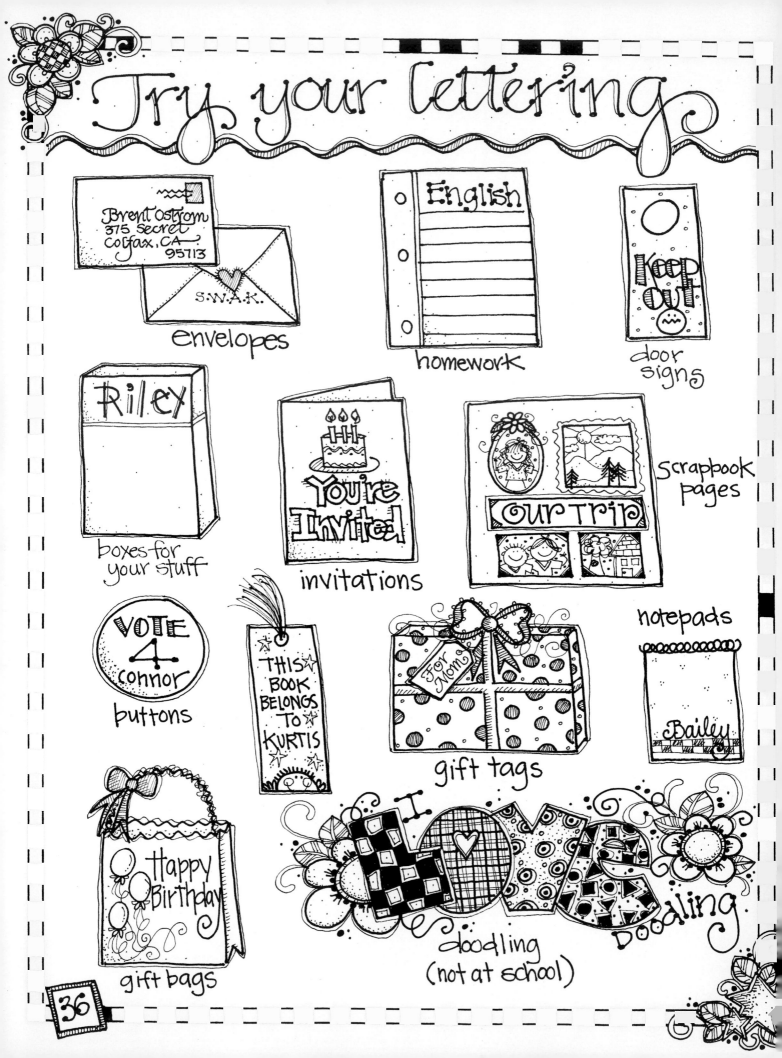

Try your lettering

envelopes

Brent Ostrom
375 Secret
Colfax, CA
95713

S.W.A.K.

homework

English

door signs

Keep Out

boxes for your stuff

Riley

invitations

You're Invited

Scrapbook pages

Our Trip

buttons

VOTE 4 connor

THIS BOOK BELONGS TO KURTIS

gift tags

For Mom

notepads

Bailey

gift bags

Happy Birthday

doodling (not at school)

I LOVE

Doodling

on stuff like this!

6th grade DANCE 🎵 🎶 🎵
Friday Night
at
ALTA DUTCH FLAT SCHOOL.

posters

FOR MOMMY

greeting cards

BUGS

labels

LEMONADE 25¢

signs

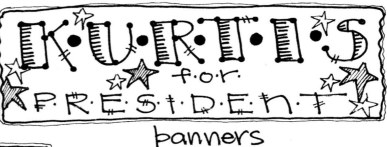
K·U·R·T·I·S for P·R·E·S·I·D·E·N·T

banners

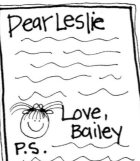
Dear Leslie

Love,
Bailey
P.S.

pen pal letters

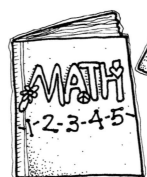
MATH
1·2·3·4·5

book covers

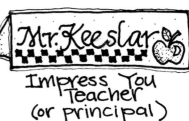
Mr. Keeslar

Impress You
Teacher
(or principal)

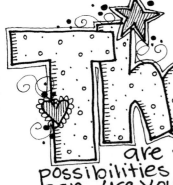
There
are so many possibilities of what you can use your lettering for. These are a few of my favorites. What else can you come up with? Let your imagination run wild!

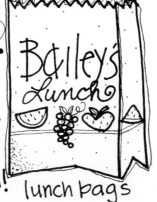
Bailey's Lunch

lunch bags

Soccer Mom

clothing

Practice makes perfect

Take these sheets to your local copy store and make as many more copies as your mom or dad will allow you to. Use this vertical and the other horizontal sheet to practice on. And practice, and practice, and practice....